C **university college for the creative arts**
at canterbury, epsom, farnham
maidstone and rochester

746.092 IKO

Canterbury, New Dover Road, Canterbury, Kent CT1 3AN 01227 817314

This book is to be returned on or before the last date stamped below.
Fines will be charged on overdue books.

05. MAR 07.

18. OCT 07.

19. 08.

2918 SEP 08

14. JAN 11

D1388147

C55159

portfolio collection **Joan Truckenbrod**

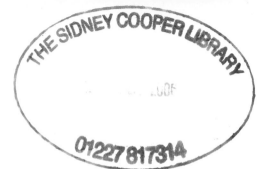

THE SIDNEY COOPER LIBRARY

01227 817314

Graphics by Katharina Riegler, Italy
Proofreader: Katherine James
Series Editor: Matthew Koumis
Reprographics by Typoplus, Bolzano
Printed in Bolzano, Italy by
La Commerciale Borgogno

© Telos Art Publishing 2005
Brighton Media Centre
Brighton BN1 1AL
England
www.arttextiles.com
editorial@telos.net

ISBN 1 902015 93 2

A CIP catalogue record for this book
is available from the British Library

The right of Joan Truckenbrod and
Polly Ullrich to be identified as the
authors of their work has been
asserted by them in accordance
with the Copyright, Designs and
Patents Act 1988. All rights reserved.
No part of this publication may be
reproduced, stored in a retrieval
system or transmitted in any form
or by any means, without the prior
permission of the publisher.
Photocopying this book is illegal.

Notes

All dimensions are shown height
x width x depth. Places named in
this book are in the USA unless
otherwise stated.

Names of Photographers

Kim Harrington, Joan Truckenbrod

Artist's Acknowledgments

It is a pleasure to thank Susan
Aurinko for her vision and en-
couragement, Polly Ullrich for the
in-depth study of my work and her
insightful essay, Kala Art Institute
for a very productive Artist
Residency, and Wolfgang Leiser
for the recognition of my work in
The Digital Art Museum. I greatly
appreciate Matthew Kourmis's
vision in the presentation of my
work. And I especially thank
Clyde Kimbal for invigorating the
creative life.

Publisher's Acknowledgments

Thanks to Paul Richardson at
Oxford Brookes University,
Christopher Springham at Luther
Pendragon and Simon Bates at
Tarlo Lyons.

Illustration pages 1 & 47:
Contrapuntal Substratum (detail)
2000
fiber installation, digital images,
dye sublimation, front panel
polyester voile, background panel
polyester charmeuse
59 x 42 x 20in (150 x 107 x 51cm)

portfolio collection
Joan Truckenbrod

TELOS

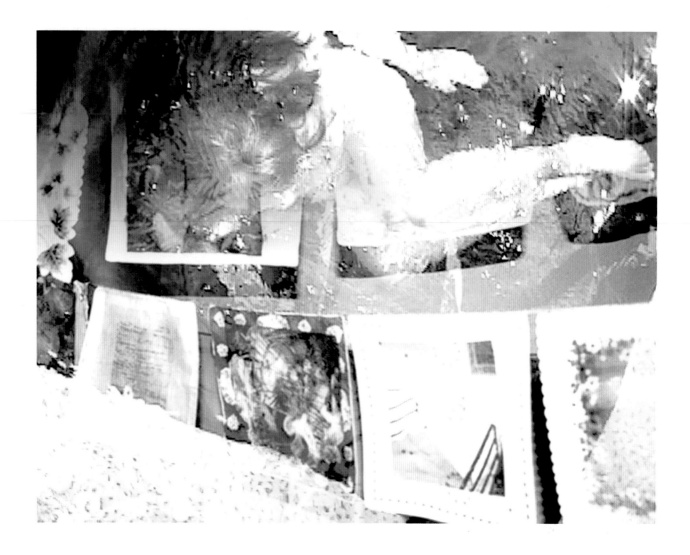

Contents

Spirits on the Wind
2003
multimedia installation
video projection, individually printed
handkerchiefs, sound, wind

Foreword Susan Aurinko

Spirits on the Wind
2003
view of the multimedia installation
video projection, individually printed
handkerchiefs, sound, wind

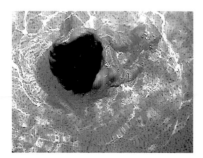 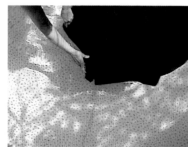 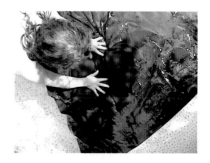

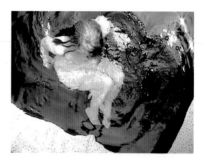

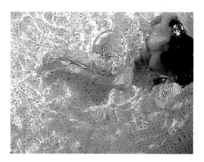

Spirits on the Wind
video stills from the projected video

I have the extreme pleasure of not only representing an artist of Joan's caliber, but also of calling her my friend. We met nearly five years ago when I opened FLATFILE-photography. Determined to be the first gallery in Chicago to legitimize digital photography, I was thrilled to receive a letter from Joan asking if I was planning to show the medium. I responded with a resounding yes, and the rest is history.

I have watched Joan, a true pioneer of digital media, grow and spread her wings, expanding first into projected installation and, more recently, into digital video installation. She is fearless, willing to try absolutely anything; which is, I believe, the secret of her continued creative success. Joan's intimate examination of issues of life and death are profound and authentic and her artistic integrity is legendary. Joan's artistic passion is matched only by her kindness and generosity. I have sent countless aspiring digital and video artists to Joan for advice or mentoring, all of whom come away not only with the answers they sought, but also with a friend for life, which I believe to be the hallmark of a true educator.

The art works in this book represent several years of work based on the metaphorical use of salmon. From the first image of salmon in the waters off the Oregon coast, to salmon in Alaska, Joan has followed the stream, so to speak, and, as she puts it, used the salmon to examine "the instability of being, the precariousness and yet preciousness of one's life". In her latest video, an amorphous fiber chrysalis is activated by two images simultaneously: the ubiquitous wild salmon, swimming eternally up-stream, and the view from a wheelchair as it travels the difficult terrain of old age. As always, Joan's work is successful on several levels, inviting meditation and introspection and at the same time delivering its message loud and clear beneath the sound of the rushing stream.

Susan Aurinko
Director FLATFILEgallery, Chicago

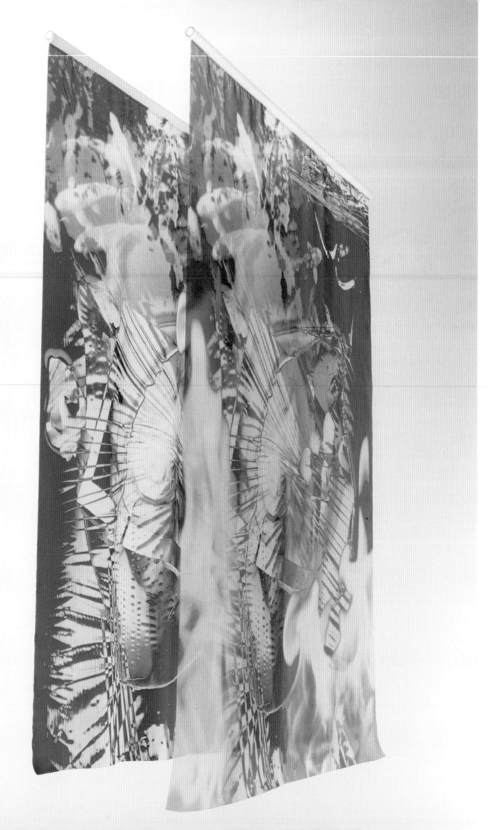

Joan Truckenbrod Polly Ullrich

Contrapuntal Substratum
2000
fiber installation, digital images, dye
sublimation, front panel polyester voile,
background panel polyester charmeuse
59 x 42 x 20in (150 x 107 x 51cm)

**"Here between the hither
and the farther shore
While time is withdrawn,
consider the future
And the past with an equal mind."**
T.S. Eliot, "The Dry Salvages" [1]

Joan Truckenbrod, one of a small, international cadre of artists who pioneered the dawn of digital art in the 1960s and '70s, has spent a lifetime knitting the world together with her art. Now, her artistic reach is far-flung, marshaling textiles, sound, video and sculpture as well as digital imagery into installations which interweave the intensity of physical reality with the resonance of invisible worlds.

Truckenbrod's interest in the 'interstitial' – or the in-between – springs from an early sense of the digital plane as a portal, as a threshold between multiple realms of experience, as a bridge between the creative ideas of artists and their kinesthetic experiential world. In physics, the interstitial often refers to those microscopic, vibrating spaces which bind atoms together in solid form, with a hum of impalpable energy percolating through the physical universe. More profoundly, however, Truckenbrod's interest in interstitial sites – whether in the physical world or in cultural mythmaking – has initiated art work which seeks out the most fundamental of realities, chronicling the human cycles of life and death as inextricably bound up with the flow of a single, natural, barely perceptible continuum.

Even as an early digital artist, Truckenbrod exhibited a drive to uncover and materialize in aesthetic form the undulating fields of sub-atomic forces which bind ordinary, daily life into a recognizable whole. At first, she was obsessed, not just with a mimetic reproduction of nature, but with "making an impression on paper that was actually nature." [2] She devised computer software programs that were based on algebraic formulas

Charma Boreale
2001
fiber installation, digital images, dye sublimation, front panel polyester voile, background panel polyester charmeuse
66.9 x 42 x 20in (170 x 107 x 51cm)

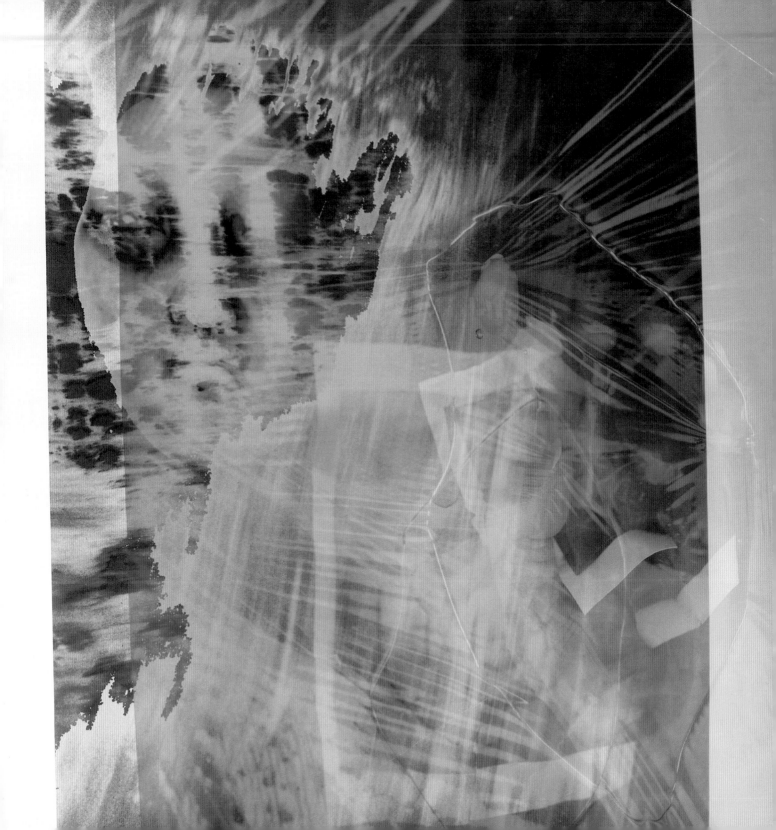

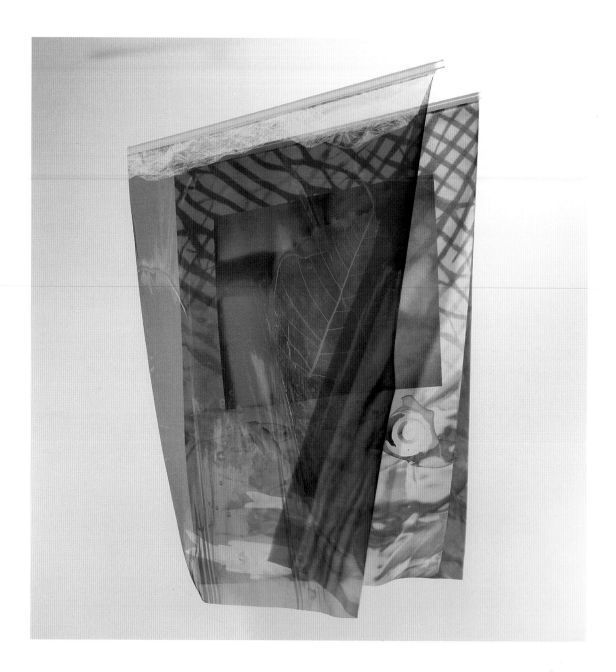

for natural forces which humans perceived as wind currents, gravity and the reflection of light. She printed out these formulas, using the only available device which accommodated a program in the early 1970s – a rudimentary 'plotter' used by geographers to print lines on a map. It was Truckenbrod's initial attempt to bridge the invisible and the visible. She has explored those fertile terrains of transition and transformation ever since.

Truckenbrod's existential work – in two forms – poses reality as a continual rush of turbulence and flow. Her universe resonates with aliveness, and its energy circulates without boundaries, connecting the internal worlds of human dreams and subatomic particles with the external world of solid physical objects. One body of work is a series of remarkable fiber installations, with digital imagery that was made possible by the invention of new technology in the 1980s and 1990s. Some of

those innovations were developed by Truckenbrod herself. Her second body of work, a group of installations incorporating sound, sculpture and video imagery (some of it digitally modified), places the ebb and flow of human life within the ravishing, dispassionate ecological cycles of the natural world.

Fiber Installations

Fiber as a connective tissue, fiber as an undulating metaphor for the interweaving of worlds, first occurred to Truckenbrod during a visit to a fabric shop in Como, Italy. Surrounded by elegant, dark mahogany stacks of fabric shelves reaching to the ceiling, the artist watched as a particularly elegant bolt of silk was taken down, unrolled and shaken out along a wide table with the flick of sheer, pliant waves.[3] The experience was to provide an enduring point of reference for the next stage of Truckenbrod's work.

Asymmetric Bodies
2000
fiber installation, digital images, dye sublimation, front panel polyester voile, background panel polyester charmeuse
52 x 42 x 20in (132 x 107 x 51cm)

15

At the time, Truckenbrod was exploring the cosmologies of aboriginal and indigenous peoples, primarily in Australia and Africa, whose creation myths singularly reminded her of descriptions of the subatomic substructure called the 'quantum continuum' by Western science. Both of these ancient and contemporary world views characterize the tangible universe as an ongoing movement of vast, underlying energy fields which periodically coalesce and stabilize into what we experience as our physical environment. It is this dovetailing of the digital/contemporary with the mythological/ aboriginal which uniquely characterizes Truckenbrod's art.

After recognizing fiber's uniquely malleable characteristics, Truckenbrod began constructing installations with two seven-foot-tall swaths of cloth hanging from a ceiling, a sheer polyester voile textile poised in front of a charmeuse panel of cloth. When installed in a gallery, the fabric resonates with the faintest breath of air, the translucent voile catching ambient light, and alternately revealing and concealing the charmeuse with a flickering rhythm. The textile's give and take allows the artist to materialize the impalpable, to show a back and forth between different but simultaneous realms. This movement, however, is not merely physical. Cloth's endless metaphorical variability, its rich associations to the life of the body and to the necessities of cultural connectedness, endows these installations with an archeology that plumbs human traditions from the earliest civilizations.

At the same time, Truckenbrod was developing layers of idiosyncratic digital imagery which Editextile, a textile printing concern in Montreal, then printed from disks onto the fabric, using a dye sublimation process. These images are deliberately partial and fleeting – of swirling and torn paper fragments or the bubbles and eddies of water – all meant to corporealize the ineffable, to bring forth the

Objectification
2000
fiber installation, digital images, dye sublimation, front panel voile, background panel charmeuse
52 x 42 x 20in (132 x 107 x 51cm)

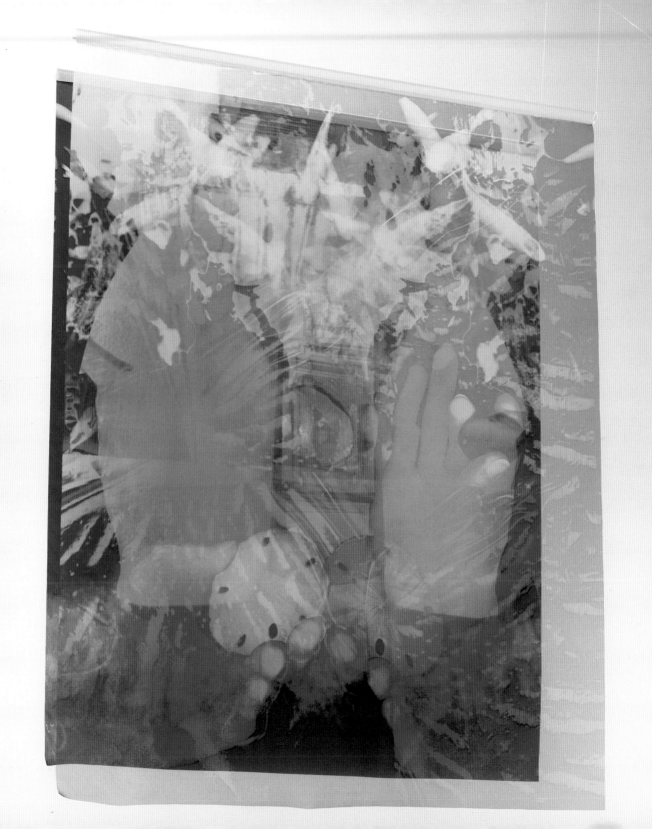

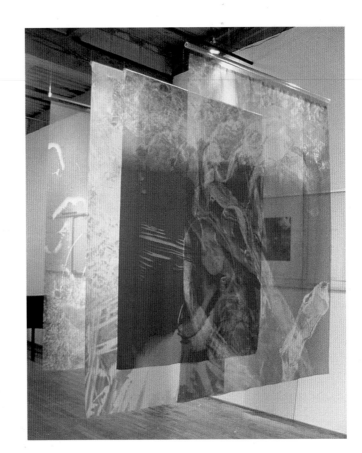

Emerge
2001
fiber installation, digital images,
dye sublimation, front panel
polyester voile, background panel
polyester charmeuse
56.3 x 42 x 20in (143 x 107 x 51cm)

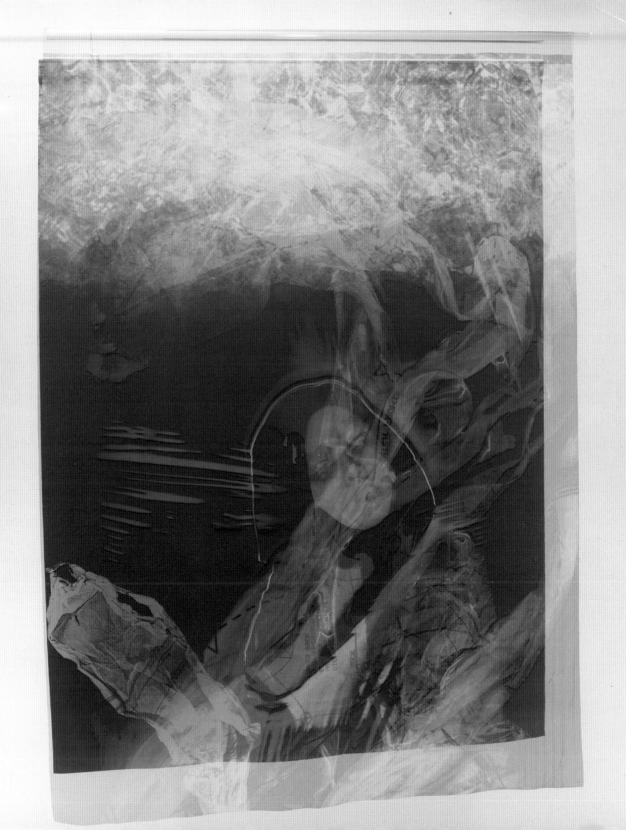

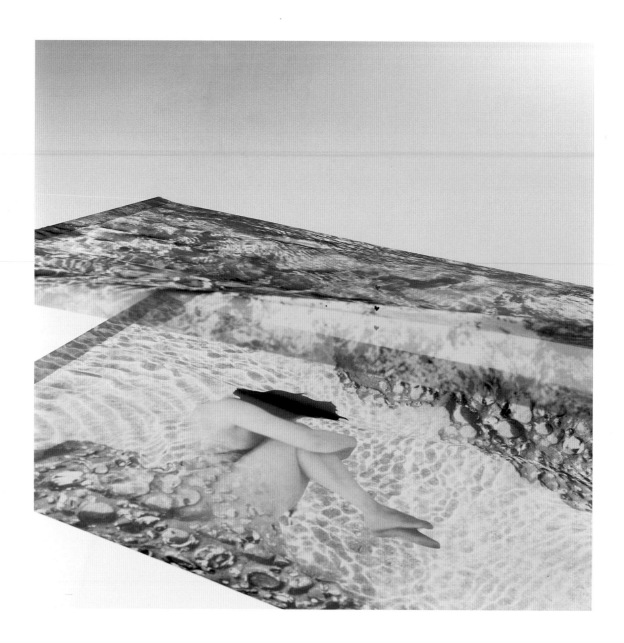

Songlines (detail)
2002
fiber/video installation, digital
images, dye sublimation, front
panel polyester voile, background
panel polyester charmeuse
70 x 42 x 20in (178 x 107 x 51cm)

intangible drama of movement
which is then laid down upon an
oscillating cloth. *Objectification*
(2000), for example, displays the
monumental image of the artist's
hand digitally scanned as it is thrust
downward into a tray of water –
the splash and the thrust are frozen
or 'objectified' in mid-air, in an
effort to magnify and to underscore
the ebb and flow of this dynamic
installation. *Emerge* (2001) pro-
vides a darker edge to the human
place within the artist's continually
unfolding universe. The viewer
perpetually sees and then loses
the image of an embedded human
face, wavering uncertainly within
the thin and oscillating strata of
black, sheer fabric.

Songlines (2002), a vibrant in-
stallation, finds interstitial ground
between the virtual and the tangible
by reverberantly mixing video,
digital imagery and rippling cloth
panels. An Australian aboriginal
term for a flow of energy emanat-
ing from the earth, the installation
represents the beginning of

Truckenbrod's thrust toward a
more densely layered, multimedia
aesthetic. The title refers to
aboriginal creation stories and to
the ancient, generative ancestral
beings who 'sang' the world into
existence by forming and stabilizing
huge swirling energy fields into all
the elements of the natural world –
and in the process imbuing the
land with life and underlying con-
sciousness. Aboriginal 'songlines'
are sites of energy resonating
on the earth as a record of these
cosmological events.

In Truckenbrod's *Songlines*, the
swaying fabric panels support an
image of a woman curled within
the pounding wash of surf and
dappled light. Ghostly video
projections of the flickering bodies
of fish animate and skim her body.
The overall effect is one of extreme
pliancy and permeability – to move
back and forth between simultane-
ous realms, Truckenbrod implies,
is to get to the heart of 'reality,'
and to gain keen understanding.

Multimedia/Video Installations

Water as magic, as the ocean of unconsciousness, as the source of the world, as a living, moving, sacred stream which embraces the physical rhythms of life, stands at the core of Truckenbrod's multi-media installations. Because of her interest in the iconography and flow of interstitial sites, the artist has repeatedly returned to the coasts of Alaska and Oregon to videotape the ocean estuaries. Estuarine habitats – which are richly fertile points of transformation between salt and fresh water – harbor the alternating flow of ocean tides as they are pushed in and pulled out of riverways by the rotation of the earth.

Subsequently, Truckenbrod began videotaping salmon runs in the northwestern United States – a dramatic natural phenomenon in which torrents of wild salmon, which gorge themselves in the rich salt water environment of the ocean, wildly surge through estuaries to swim and jump up-stream against strong currents and waterfalls into freshwater rivers and lakes. There, following their sense of smell to the place of their birth, they spawn, bury their fertilized eggs under rocks and die. Their decaying bodies provide food for a new generation, which makes its way back to the ocean and begins the cycle again. The frenzied run of the salmon – propelled by a joyful life force which ends in death (but leads to the rebirth of the life cycle) – offers a stunning image for Truckenbrod's themes of flow and transformation. Every installation produced by the artist in the last several years incorporates images and the sound of the salmon's headstrong rush toward the journey's end.

In *Quantum Realities* (2002), for example, a floor installation, we look down from a darkened envi-ronment into a bright, deep hole – like a portal. The hole, filled with water and surrounded by stones,

Quantum Realities
2002
multimedia installation
video projection, sound, water, sand, river pebbles
58 x 42 x 3in (147 x 107 x 8cm)

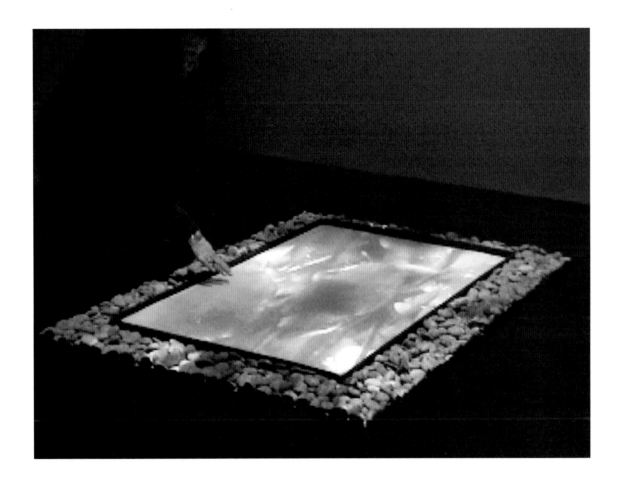

opens into a series of luminous, flapping, splashing video images of salmon. *Quantum Realities* is surely meant as an existential peek into the relentless, but not unsatisfying, rush of natural forces that bind up all living things.

Animated video imagery contributes to the sharp aliveness in these installations, but the pounding, trickling, splashing, roaring and cascading of water sounds permeating the art also heightens its physicality. The sound of flowing, acoustically amplified water knits together all elements of the installations. It conveys a sense of overwhelming physical immersion (there is an impression of exploring the art from the inside, not from the outside). But sound also allows Truckenbrod to reinforce her theme of the interstitial, of the mediary. Sound – as energy coming from sound waves which physically move through space and into the ear – perfectly straddles the material and the immaterial. It is

both present and physically absent. It acutely re-creates Truckenbrod's idea of flow and flux.

Immersion, after all, is not only the method but the content of Truckenbrod's multimedia installations. In a delicate progression toward what seems like a light at the end of a tunnel, she continues to refine and zero in on the inescapable and the fundamental – the human submersion in natural cycles of life and death. *In Spirit Site* (2002), for example, the model of an empty white house suspended from the ceiling of a darkened gallery is awash with streaming video images of salmon and with water sounds. The bright images, projected through the windows of the house, flow over photographs of elderly human faces mounted behind window frames on an adjacent wall. The empty house; the stern and lined old faces; the rush of light, sound and fish: all speak of struggle and transformation.

Spirit Site
2002
multimedia installation
video projection, model house
suspended from Gallery ceiling,
sound, window frames on walls
with photographic images

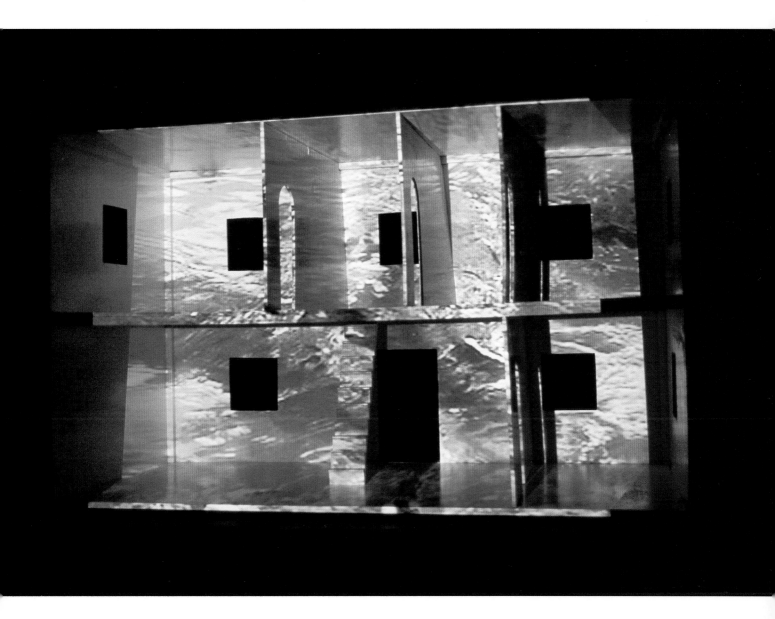

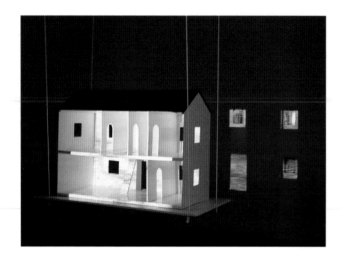 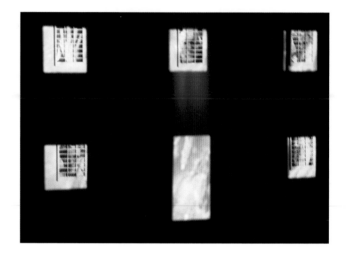

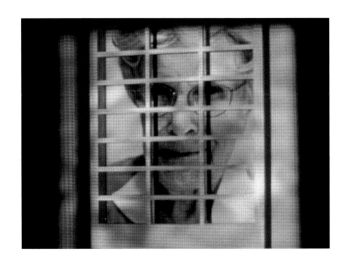

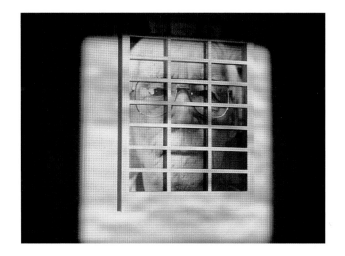

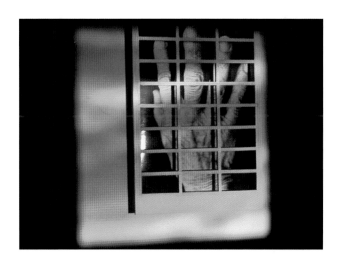

 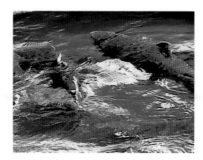 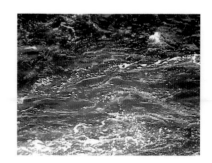

pages 26 & 27:
Spirit Site
2002
multimedia installation
video projection, model house,
sound, window frames on walls
with photographic images

above:
Spirit Site
video stills from the projected video

Against the Current (2004), another estuarine installation, features a hospital bed with crumpled white sheets flickering with the glowing video of a woman floating and pushing herself against the flow of running water. Truckenbrod has digitally interwoven this image with a salmon run, so that fish and human bodies mix and pulse together over the bed's white furrows. Small sculptures of salmon knitted with sterling silver wire and stuffed with moss lie nearby on the floor. It is easy to think of a hospital bed as a discordant piece of furniture in an art gallery – until one realizes that hospitals are where many people reach the end of their lives.

Few contemporary artists like Truckenbrod dare so forthrightly to contemplate such fundamental themes. While identity politics in this Postmodern age of irony are awash in the suspicion of any human condition that could remotely be thought of as universal, Truckenbrod's art goes deep; it speculates upon what most profoundly lies at the heart of every living thing. "We knew, or at least had a premonition, that we held death in us, like the fruit in a stone," writes Rainer Maria Rilke.[4] In that sense, Truckenbrod perhaps finds herself in the company of Bill Viola, whose resonant video installations also contain the breath of existential meaning.

Truckenbrod's *Lightening in my Blood* (2004), an enormous, shimmering organza and wire sculpture of a chrysalis suspended from a ceiling, reiterates that sense of movement, of passage from one reality to another in her art. The cocoon, a primordial symbol of metamorphosis and transition, vibrates with interwoven video images which seem to push and strain from inside the form. Video shots of jumping salmon overlap shots of a nursing home, whose aging residents are engaged in an end of life struggle. It is a juxtaposition which once again drives home the artist's search for interstitial terrains – whether virtual or physical – and speaks for the currency of aboriginal and ancient ways of thinking in contemporary art.

Polly Ullrich
is a writer and art critic living in Chicago.

NOTES
[1] T.S. Eliot, "The Dry Salvages," in *Four Quartets* (San Diego, New York, London: Harcourt Brace & Company 1971): 41-41.
[2] Author's conversation with the artist, Spring 2003.
[3] Joan Truckenbrod, "Dye Sublimation Printing on Silk," *TextileForum 4*, (December 2000): 37.
[4] Rainer Maria Rilke, "Death on Ulsgaard," trans. Gertrude Weihs and Peter Bailey, unpaginated, www.reddogpieface.com/rilke.html.

Against the Current
2004
multimedia installation
video projection, hospital bed,
crumpled white sheet, hand-knit
salmon, motion sensor, hidden
lights and sound

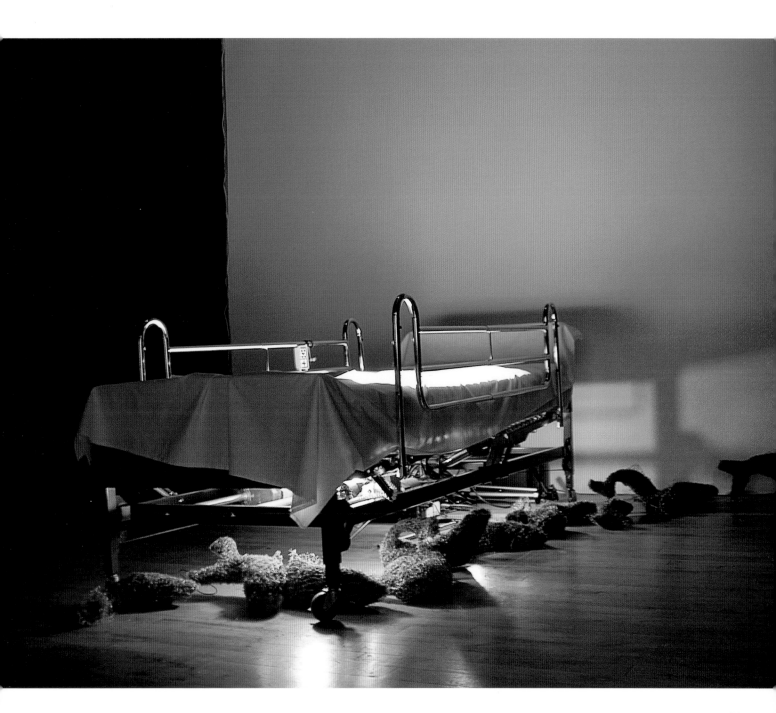

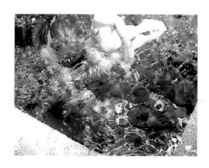

pages 32 & 33:
Against the Current
video stills from the projected video

pages 34 & 35:
Against the Current
video projection into crumpled
sheet on hospital bed. Hand-knit
salmon of silver wire, with moss.
These salmon move through the
gallery space, under the bed, as if
moving upstream in a salmon run.

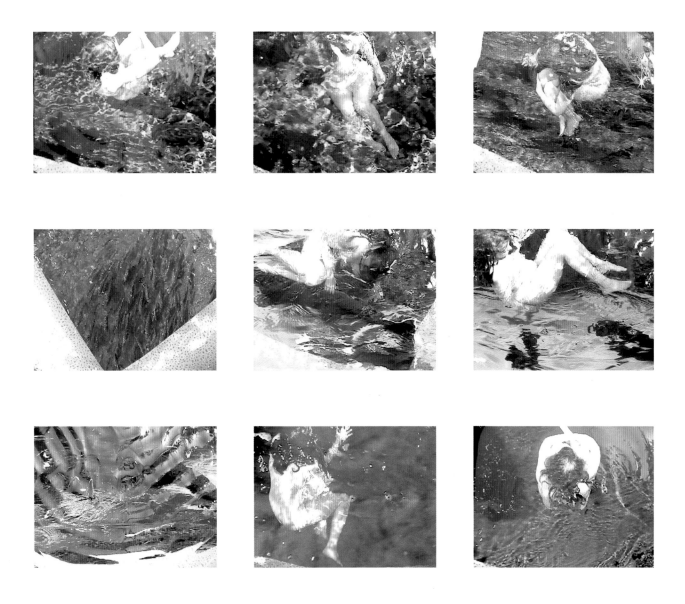

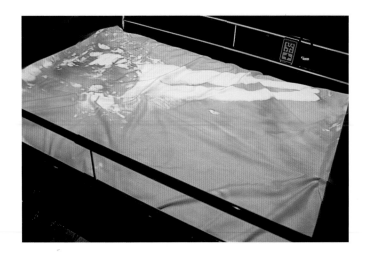

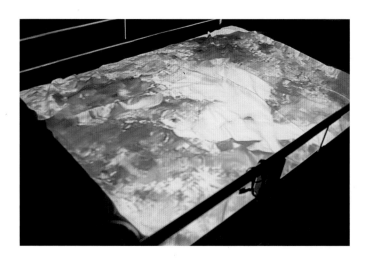

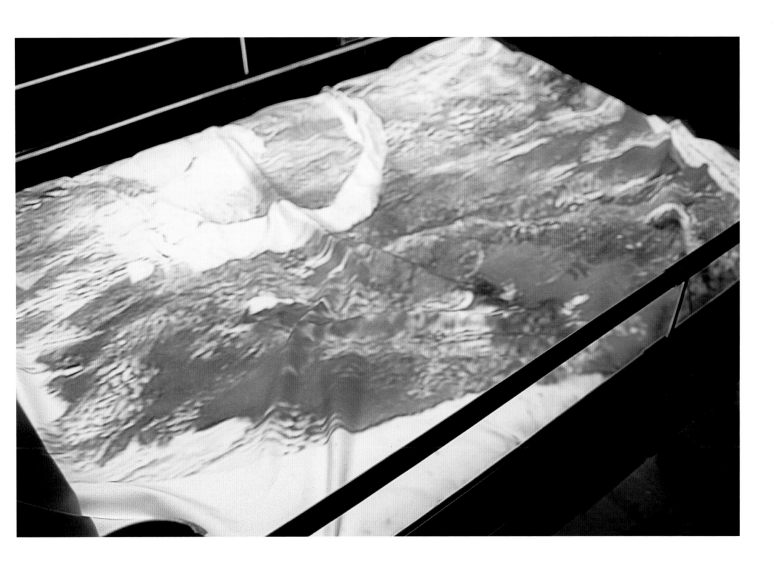

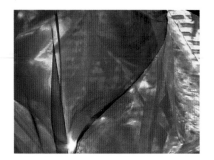 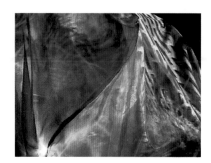 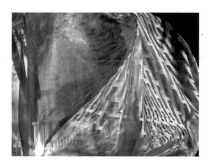

pages 36 & 37:
Lightening in my Blood
2004
multimedia installation
handmade fiber chrysalis, two
simultaneous video projections,
sound
84 x 52in (213 x 132cm)

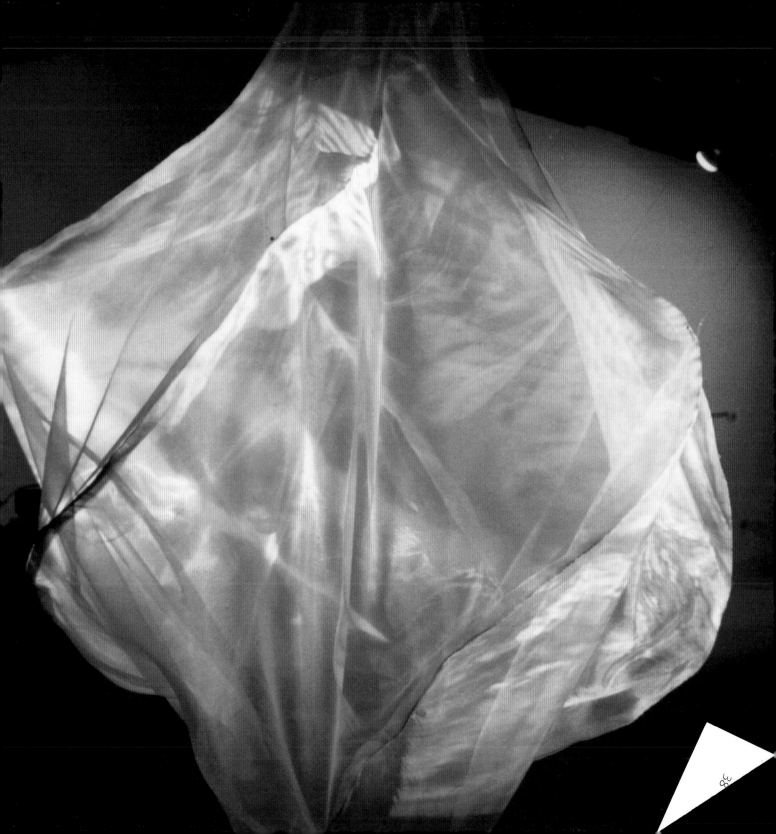

pages 39-43:
Lightening in my Blood
video stills from the two
video sequences projected
simultaneously into the chrysalis

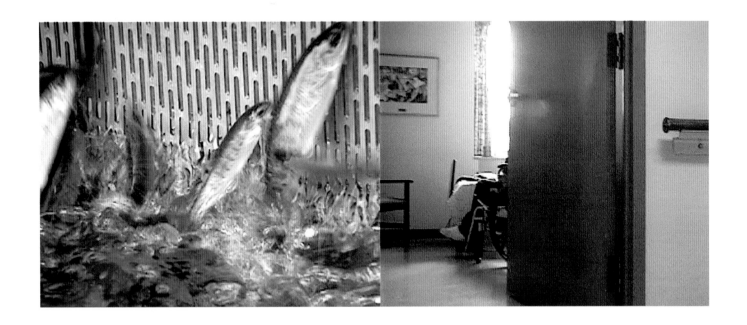

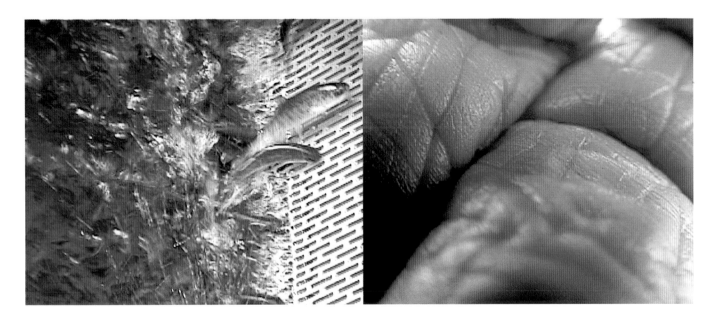

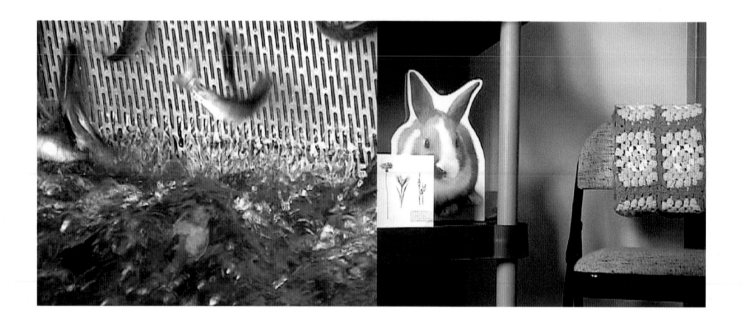

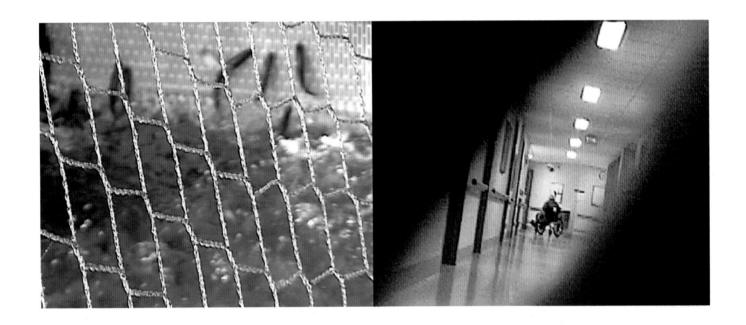

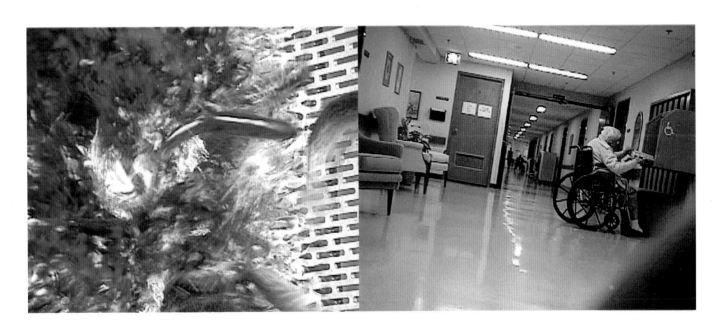

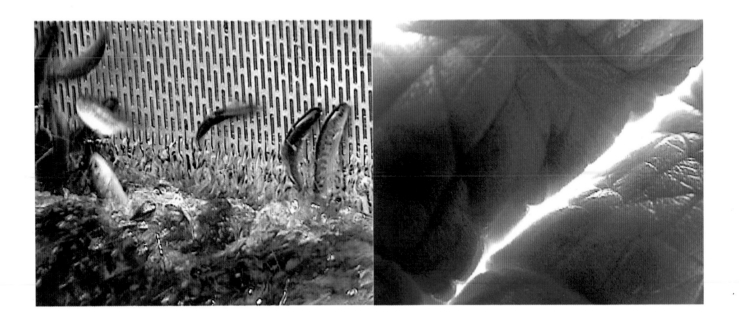

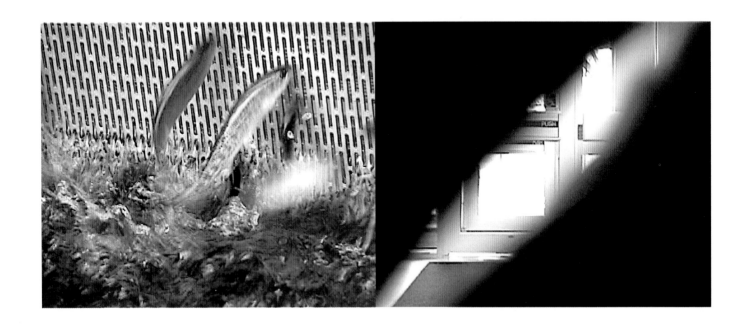

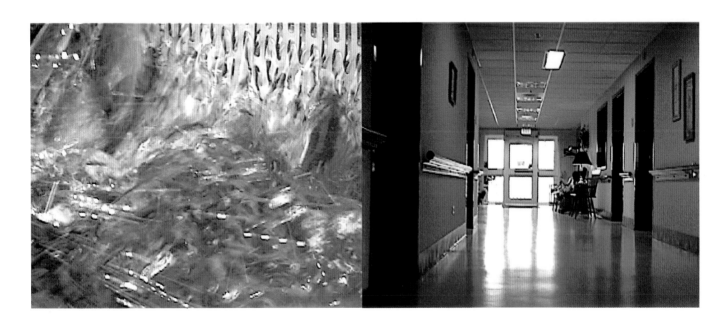

Biography

Joan Truckenbrod
Professor, Art and Technology Department, The School of the Art Institute of Chicago

Education
1967 B.A, Beloit College, Beloit, Wisconsin
1979 M.F.A., The School of the Art Institute of Chicago

Selected Solo Exhibitions
2004 FLATFILEgallery, Chicago
2003 FLATFILEphotography Gallery, Chicago
2002 FLATFILEphotography Gallery, Chicago
2001 Galerie der Gegenwart, Wiesbaden, Germany
2000 'Glaz'art', Paris, France
2000 'The Cube Gallery, Kansas City, MO
1999 Wright Art Center, Beloit College
1998 Colville Place Gallery, London, UK
1996 Illinois Art Gallery, Chicago
1989 Villa Chianni, Lugano, Switzerland

Selected Group Exhibitions
2004 'Fellowship Exhibition', Kala Art Institute, Berkeley, CA
2004 'High Fiber', Kala Art Institute, Berkeley, CA
2003 'Fiber Focus 2003', ART St. Louis, Missouri
 'Awarded Surface Design Award' by Curator Junco Sato Pollack
2003 'Transition', IUN Gallery for Contemporary Art, Indiana University NW, Gary, Indiana
2002 'Rays of Light Exhibition', Lightology Gallery, Chicago
2002 Gallery 2, Chicago, Juried Exhibition
2001 Betty Rymer Gallery, Chicago
2001 'Selected Works', Digital Salon, Corning Gallery, New York City
2001 Glasgow School of Art, Scotland
1999 Intermedia Arts, Minneapolis
1998 Digital Salon, Visual Arts Museum, New York City

1998	'Pioneers of Digital Photography', Open Space Gallery, Allentown, PA
	webs://textiles & new technology, University of California, Davis
1997	'Electronic Immersions', Illinois Art Gallery, Chicago
	'Digital Perspectives', Ukrainian Institute of Modern Art, Chicago
1996	'Images du Futur 96', Interactive Installation, Montreal, Quebec
1994	Lahore Alhamra Art Center, Lahore, Pakistan
1991	Museu de Arte Moderna, Rio de Janeiro, Brazil
	InterMedia Arts, Minneapolis, Minnesota
1987	Everson Museum of Art, Syracuse, New York. Traveling Show: Contemporary Art Center, Cincinnati, IBM Gallery, New York City, Dayton Art Institute and White Museum at the University of California
1985	Film/Video Arts, New York City
1983-84	Musée d'Art Moderne de la Ville de Paris, Paris, France

Grants and Fellowships

2004	Kala Art Institute, Berkeley, California, Artist in Residency Fellowship
1998	Fullbright Fellowship, Research Scholar's Fellowship
1994	Scandinavian American Foundation Fellowship
1994	Illinois Arts Council Artist's Completion Grant

Publications

1988	*Creative Computer Imaging*, Prentice Hall

Artwork featured in Books

2005	*Virtual Art and Artists*, Frank Popper, MIT Press
2004	*Art in the Digital Age*, Bruce Wands, Thames & Hudson
1998	*Computers in the Visual Arts*, Anne Morgan Spalter
1993	*Art in the Electronic Age*, Frank Popper, Thames & Hudson
1991	*Photographic Possibilities*, Robert Hirsch
1987	*Digital Visions*, Cynthia Goodman

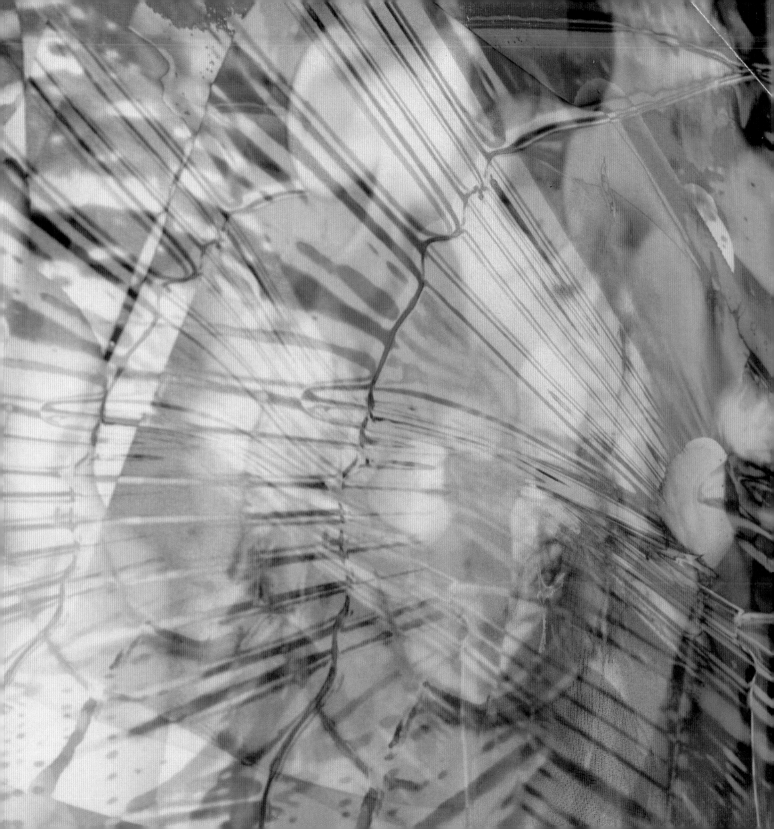

10554 Dawsons £14.95 —

Other titles in this series

Vol 27: Susan Lordi Marker
by Hildreth York
Lordi Marker manipulates silk and linen through cloque, devoré and the addition of oxides or gold leaf.
ISBN 1 902015 41 X

Vol 29: Fukumoto Shihoko
by Uchiyama Takeo
Fabulous indigo-dyed silk hangings infused with the Japanese sense of wonder for nature.
ISBN 1 902015 61 4

Vol 30: Cynthia Schira
by Joan Simon
Schira integrates woven structure and image, rendering them physically and visually inseparable.
ISBN 1 902015 63 0

Vol 31: Kumai Kyoko
by Ryoko Kuroda
Kumai's sculptures and installations use stainless steel filament in a unique way.
ISBN 1 902015 65 7

Vol 32: Susie Brandt
by J. Courtney and S. Sachs
Susie Brandt harvests detritus from middle America to fashion bedcoverings and installations.
ISBN 1 902015 67 3

Vol 33: Darrel Morris
by A. Ferris and A. Wiens
Artist and storyteller Morris uses embroidery to explore issues such as bullying, poverty and power.
ISBN 1 902015 69 X

Vol 34: Pauline Burbidge
by J. Duffey Harding
Burbidge's instinctive response to colour, shape and form infuses her collaged and manipulated work.
ISBN 1 902015 71 1

Vol 36: Merle Temkin
by Lois Martin
Temkin erases the line between the craft of needlework and the fine art of paint.
ISBN 1 902015 92 4

Vol 38: Norma Starszakowna
A former designer for Issey Miyake, she probes the surface in virtuoso print experiments, drawing on the urban environment and identity.
ISBN 1 902015 95 9

Please visit our website for details of all other volumes in this growing series.
www.arttextiles.com